THE GREAT MASTERS OF ART

EGON SCHIELE

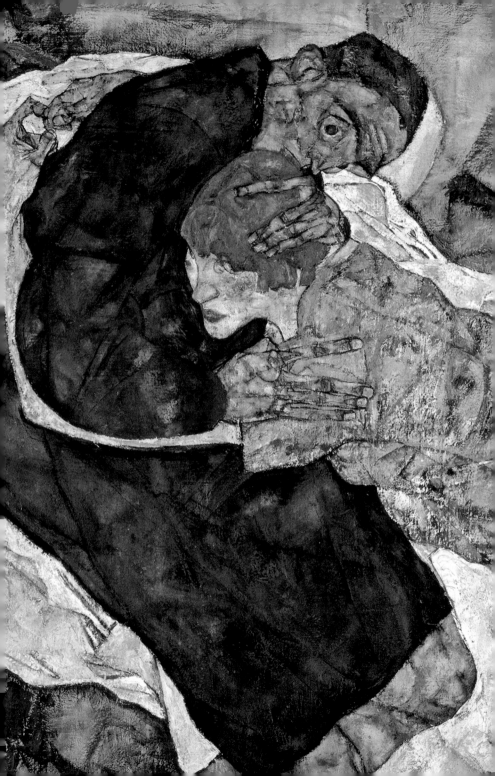

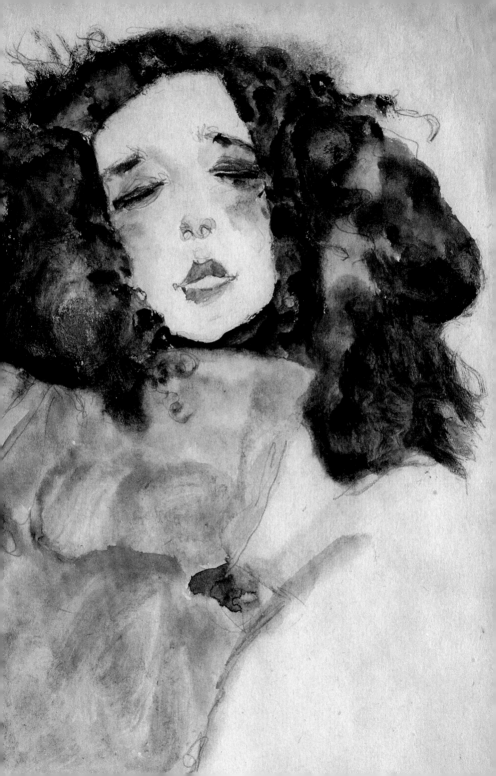

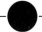

EGON
SCHIELE

Diethard Leopold

HIRMER

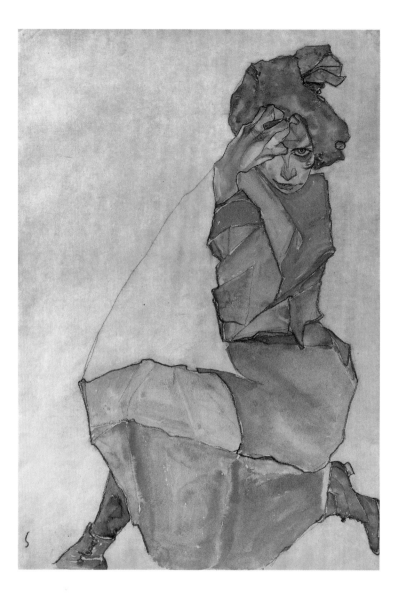

EGON SCHIELE

Kneeling Woman in Orange-Red Dress, 1910
Black chalk and gouache on paper, 44.6 × 31 cm
Leopold Museum, Vienna

CONTENTS

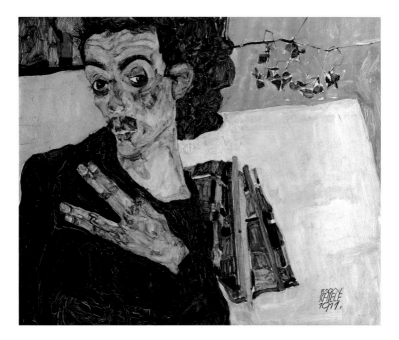

1 *Self-Portrait with Black Vase and Spread Fingers*, 1911, oil on wood, 27.5 × 34 cm
Wien Museum, Vienna

"I, ETERNAL CHILD"

Diethard Leopold

I grew up with Schiele. His pictures hung in the largest and finest rooms in our house. It was impossible to escape the vistas of his figures, his housescapes, his women and above all his gazes. I encountered them in a wide variety of situations and moods, and time and again they revealed to me ever new layers of meaning.

Today, the Schiele Collection, which my father Rudolf Leopold started compiling in the 1950s, is a central part of the Leopold Museum in Vienna. The pictures grew from our home out into the world. No problem there. But they also had a good time with us in the eyes of the children, where a particular kind of perception accorded with the wish of the artist for people to "see into" his pictures and have "contact" with them (see p. 75).

What is different about the gaze of a child? For a child, pictures are part of reality. When children devote themselves to something, then the thing in question lives in a multisensory manner. Children know *how* the world *tastes*, because they know to start with that it does taste. Children approach pictures with the same intensity. They let themselves into them. Pictures for children are not just visual information, but experiences, play spaces.[1] And precisely this is what the young Egon Schiele wanted. He referred to himself as "I, the eternal child". With his pictures, he brought "gifts", through which he sent "eyes and shimmering tremulous air". As in a ritual procession, he laid out, he said, "easily negotiable paths" before them, "and – did not speak".[2]

Above all in his earliest, most important phase, from 1910 to 1915, there wafts an atmosphere of inexplicability, of fascination and of synaesthetic sensuousness: "I want to be alone. To go to the Bohemian Forest. (…) I want to taste dark waters, see crunching trees, wild airs; I want to gaze in awe at mouldering garden fences as they all live, hear young birch groves and trembling leaves; want to see light, sun and enjoy wet green-blue evening valleys, feel goldfish shine, see white clouds building. I want to speak to flowers, flowers. Look intently at grasses, pink people, know what venerable old churches and little cathedrals are saying; want to keep running without restraint on to rounded grassy slopes across wide plains; want to kiss the earth and smell warm mossy flowers (…)."[3]

THE HERMITS
———

Of the many pictures that surrounded me as a child, the *Hermits* (fig. 2) was perhaps the one that had the most lasting effect on me. Schiele said of it that it had "arisen out of pure depth of feeling."[4] He was seeking to represent an existential feeling (see p. 72).

In the literature relating to this picture, you can read who the persons depicted may have been in Schiele's life, what they are holding in their hands, and what the dried rose near the bottom edge on the left may signify. But what a childlike "looking into" perceives, first of all, is the "surge" of the picture as a whole, the shapes and colours, the black mountain massif, built up with a subtle structure, from which, right at the top – like unattainable peaks – two heads rear out, two faces, one looking sharply downwards, the other caught in a dream.

The two men are in delicate equilibrium, heavy and yet fragile, powerful and yet sensitive – "a combination of monumental, almost abstract form and the strongest-possible expression".[5] I stood before it as a child as before an open-sesame door that did not distort its cave because it was itself the treasure: the intermeshing structure of lines and blocks, the geometry of an idiosyncratic black crystal. The faces, by contrast, I found threatening, above all the grim, concentrated look of the younger man. It was totally unclear to me what he actually wanted from me – or from himself? The face of the other, older person, by contrast, disconcerted me by dint of its soft, dreamy, madness.

2 *The Hermits*, 1912, oil on canvas, 181 × 181 cm
Leopold Museum, Vienna

The two figures are enmeshed and as it were fused into a single form. Carl Reininghaus, an early collector of Schiele's works, remonstrated with the artist on that account: the mutual positioning of the two figures was unclear, he said. Schiele responded with a detailed description of the picture, in which he emphasised that he was not concerned with real figuration, but with spiritual significance:

"(…) that I painted them so pale was intentional, otherwise the poetic thought and the vision would be lost, as would the indeterminacy of the figures, which are intended to look crumpled, the bodies of those tired of life, of the suicidal, but also people of feeling. See the two figures as a cloud of dust which, like the earth, seeks to build itself up but has to collapse,

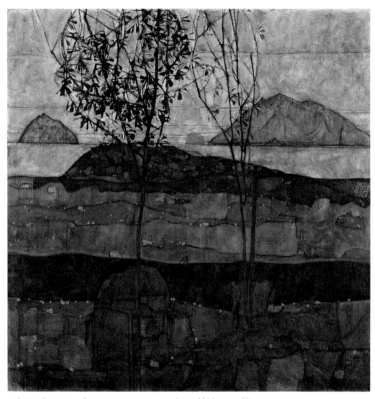

3 *Setting Sun*, 1913, oil on canvas, 90 × 90.5 cm, Leopold Museum, Vienna

powerless."[6] Rudolf Leopold thought, accordingly, that in this picture "the form of appearance [had been] replaced by ... a highly unusual form of experience".[7]

For a long time, people claimed to see Gustav Klimt in the presumably older man, although Schiele himself leaves this open. One could just as well see an allusion to Schiele's dead father,[8] for in the same letter to Carl Reininghaus the artist wrote: "I could not have painted the picture from one day to the next, but through my experiences over a number of years, from the death of my father onwards; I painted more a vision than pictures on the basis of drawings."

One strange circumstance indicates that the two figures could however represent two aspects of a single person: the two hands emerge from

sleeves of different lengths; in other words, the two men are both holding the large portfolio of drawings – an important fact not previously noted, and one which struck me when I was squatting on the floor in front of the picture in order to experience once again what I felt as a child in this position.

This picture, then, intends to say that art draws on two different human capacities: the conscious, volition-based on the one hand, and the abandonment to dream and inner vision on the other. The two figures are inward images, psychological archetypes, and the *Hermits* consequently a double self-portrait in the deepest sense. The picture aims to integrate these two aspects into one complex personality.

In point of composition, too, the fusion of opposites has succeeded in an inimitably masterly fashion: namely as the integration of an ardent, emotional happening with a formally tension-rich, but almost abstract pictorial structure.

Many viewers find the significance of the half-dried-out rose puzzling. For me as a child, though, there was nothing enigmatic about it at all. The flower was simply the epitome of this picture's closeness to me. For me, it was "intimate", and today I would say it is the embodiment of "intimacy": sweetly scented and painfully moving at the same time. And its semi-desiccation brings out its graphic qualities in a very natural manner: it is delicate, sensitive – just as Schiele's trees can be (figs. 3, 12).

"EMPFINDUNGSMENSCHEN"

Egon Schiele is one of those artists whose compositions have entered the collective cultural memory. In his case, it is not so much an individual work as a particular style that we identify with him: the way he draws lines; the kind of colours he uses; the way he structures the landscape of human bodies and faces, houses, hills and leafless trees. And the particular themes that were important to him and still affect us today: sexuality and death, loneliness and dream, outward poverty and inner riches – a whole world built of feelings, be they those of the body, or deeply felt thoughts. Schiele was in the depth of his being a "lyricist" (fig. 4). As such he exerts a subliminal and enduring influence particularly on young people, and especially on artists – and not on art history in the narrower sense, but on

culture and sensibility in general. Schiele has become part of us. A sensitive aesthete on the one hand, (fig. 5), a taboo-breaking expressive artist on the other (fig. 6), at the mercy of moods, eccentric, carefree, a sensualist, someone who took his dreams seriously. At the same time well-mannered and quiet, well-dressed, and outwardly restrained.

He found role-models for this lifestyle in Baudelaire and Verlaine, in Hofmannsthal and Rilke, but above all in the poet Arthur Rimbaud. He had even learned the long poem of the "drunken ship", *Le Bateau ivre*, which had just appeared in German translation, by heart.

4 *The Lyric Poet*, 1911, oil on canvas, 80.5 × 80 cm
Leopold Museum, Vienna

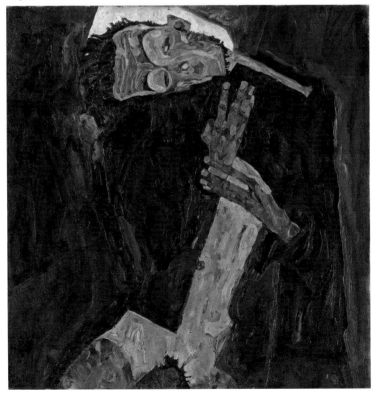

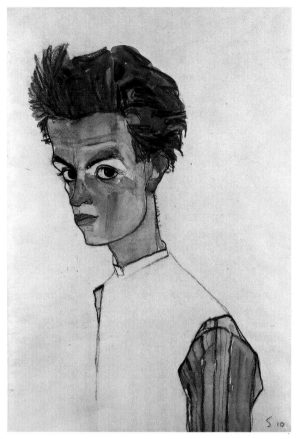

5 *Self-Portrait with Striped Shirt*, 1910, black chalk and gouache
on paper, 44.3 × 30.5 cm, Leopold Museum, Vienna

More sweetly than the flesh of sour apples seeps
through a child, green water entered my hull of pine
washing me of the blue wine stains and vomit
tearing anchor and rudder away.

And from that time on I bathed in the Poem
of the Sea, lactescent and infused with stars,
devouring the azure verdant verses, where, flotsam enrapt
and wan, a pensive drownee now and then descends.

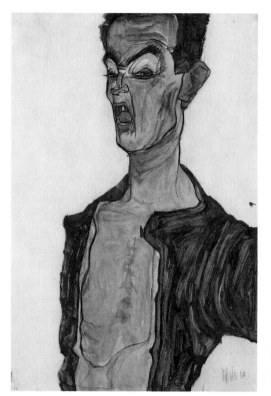

6 Self-Portrait, Grimacing,
1910, black chalk and
gouache on paper
45.3 × 30.7 cm, Leopold
Museum, Vienna

A strong personality has at least two diametrically opposite sides, which,
in him, are combined into a novel unity. In Schiele's case, this was on the
one hand a concise, soberly analytical sense of form. World and figures
crystallise beneath his gaze into poignant spatial geometries. The models
were Viennese Art Nouveau, also known as Jugendstil, with its emphasis
on constructive forms, and above all its master, Gustav Klimt.

On the other hand, Schiele was more sensitive to life than others. In his
case, we can with truth speak of a compulsion to face up to life's most
important questions – sensuousness, sexuality, transience and death,
self-assertion, loneliness and dedication, the search for meaning and
sensuous spirituality – with unconditional urgency. He either swept aside
or even failed to recognise taboos that imposed a veil of silence on these
questions.

For this reason, Schiele thought incessantly about himself and his personal development. He struggled with himself just as he did with the world. He understood his art as being in the service of the intensity, the essentials of life. The deeper truths of this life had to be preserved in the face of all resistance. He was therefore deeply disappointed, indeed dumbfounded and aghast, when he was locked up for having dared to devote himself to the questions of existence without regard to taboos.

IN THE PRISON OF HIS SELF

Schiele's brief sojourn in provincial Austrian gaols – remand in custody in Neulengbach from 13 to 30 April 1912 and transfer to the district court in St Pölten, where he was imprisoned from 4 to 7 May – took place precisely in the middle of his creative life, which lasted from 1906, when he was 16, until his early death at the age of 28 in the autumn of 1918. In addition, his arrest and imprisonment, brief though it was, marked a clear caesura in his œuvre: while the previous works had been characterised by extreme, not to say exhibitionist self-expression (fig. 7), mystical symbolism (fig. 8) or

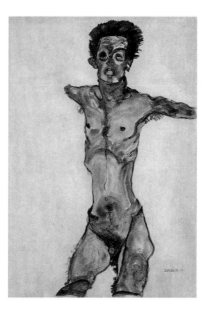

7 *Nude Self-Portrait in Grey with Open Mouth*, 1910, black chalk and gouache on paper, 44.8 × 32.1 cm Leopold Museum, Vienna

extreme physicality (frontispiece, p. 8) and thus went hand-in-hand with sexual motifs that were altogether free from taboos (fig. 9) – in other words what we nowadays call "Schiele" – afterwards both the inward and outward situation calmed down, albeit not without a deep personal crisis. Schiele subsequently found his way to more objective, more detached formulations of what had been the cause and trigger of his inner tensions. Direct self-expression turned into talking about himself.

Schiele's imprisonment was however not only what he himself, his friends and promoters made it out to be, namely a philistine attack on a freethinker and destroyer of taboos; it was also the understandable condemnation of Schiele's all-too-casual approach to under-age models. In that

8 Raven Landscape, 1911, oil on canvas, 95.8 × 89 cm, Leopold Museum, Vienna

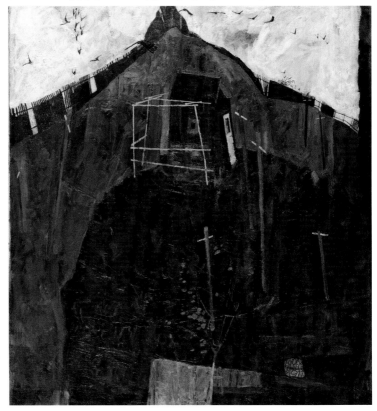

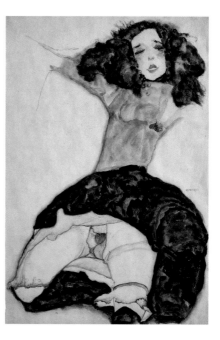

9 Black-Haired Girl with Lifted Skirt, 1911, pencil and gouache on paper, 55.8 × 37.9 cm, Leopold Museum, Vienna

sense, the lenient judgement was handed down on a regressively fixated sexual disposition.[9]

It is impossible to reconstruct precisely what happened. Schiele in any case denied any guilt in this regard. He presumably never committed any actual abuse. His lover at the time, Wally Neuzil, who would certainly been aware of any such behaviour on his part, stood firmly by him. At the same time Schiele's demeanour following his release showed how seriously and in-sightfully he saw the context of the events, and how he utilised the trial, which both profoundly disturbed him and threatened his livelihood, for his later work.

While on remand, Schiele produced watercolours on which he wrote portentous words, something he did not normally do, for example: "Art cannot be modern; art is essentially eternal" or "The orange [which Wally had brought to him in prison] was the only light". He depicts himself in the penitential garb of a monk; refers to the crisis into which he was plunged with vigorous pathos: "To inhibit the artist is a crime, it is the murder of incipient life!" (fig. 10) At the same time, though, he clear-headedly formulated his position thus: "I feel not punished, but cleansed."

After his release from jail, Schiele never again depicted children or teenagers in suggestive poses. There was no relapse into his old obsessions. He obviously had more mature inclinations at his disposal. Even so, it took nearly a year following the deep disillusionment of his arrest before he could find a new language, a newly integrated self.

For months, Schiele did not know what or how he should paint. He went through long phases of what seem like depression. In September, for example, he wrote: "I have continually to face the evil thoughts that I am not working and go on and on waiting. Since March I have not been able to paint or above all to think."[10]

Even a look back at the extraordinary œuvre of the expressive years was unrealistic, as it drew a negative balance: "(…) I wanted to start a new life. – But so far I have not been able to; – I have still not succeeded in anything in my life."[11]

The first important post-imprisonment painting was a picture whose present whereabouts – if it survives – are unknown: *Resurrection* (fig. 11). In a letter to Arthur Roessler dated 9 February 1913, Schiele described it as a "picture of the dimensions of the Hermits" – doubtless referring not only to the material dimensions, but also to the immaterial importance of the picture.

Why should a 22-year-old paint two open coffins, in which two or three people are moving once more? The "death wish" attributed to turn-of-the-century Vienna is here negated, overcome. Even in the black-and-white of the only surviving photograph we can feel the unstoppability of the movement, the self-extraction from a life that has become sterile. Schiele was evidently giving expression here to an existential process.

In traditional iconology, as in depth-psychology, spending time in a closed space and the resulting quasi-miraculous resurrection play a particular role: they are the expression of the finding or generation, as the case may be, of a new self.[12] The phoenix rises from the ashes, a new being arises from the hermetically sealed alchemistical crucible.

Schiele depicts the alternative possible processes. In the top coffin, where the person coming back to life, a woman, is still half enmeshed in death, and not yet completely clear-eyed, we can discern the presence of a second person, holding the hand of the first. Is twosomeness, "dividuality"[13], a

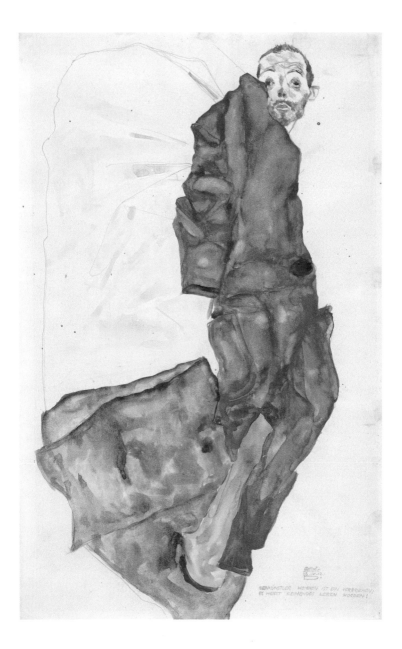

10 *To restrict the artist is a crime, it means murdering germinating life!*, 23 April 1912, pencil and
watercolour on primed Strathmare Japan paper, 48.5 × 31.5 cm, Albertina, Vienna

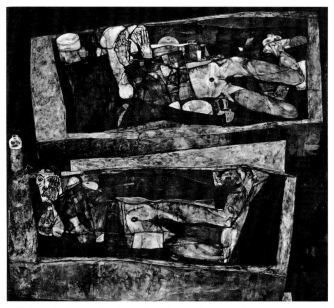

11 Photograph of the painting *Resurrection* (whereabouts unknown)

condition for resurrection? At the same time the person in the bottom coffin, alone and self-sufficient, already displays a more open gaze.

FAREWELL TO WALLY

There were decisive changes in Schiele's outward life too. He moved from the country back to Vienna, rented a studio in a fairly prosperous district, enjoyed increasing success with collectors and at exhibitions, got to know the Harms family, separated from the lower-class Wally Neuzil, and finally married the middle-class Edith Harms.

"Wally, who as an artist's model enjoyed a reputation hardly better than that of a prostitute, would never have been a socially acceptable wife for Schiele," writes her biographer.[14] But neither was Edith in a position to bring a significant sum of money into the marriage. Schiele, as his mother was to put it later, took "a girl from a petty bourgeois milieu, following the call of his heart."

We should, then, neither romanticise the relationship with Wally, which was so important to Schiele, nor lament the separation, for this relationship typified from the outset the gradient between artists and their models, in other words of relationships characterised by dependency and differences of intellectual and also economic status. It was not unlike the relationships with the under-age models: just as Schiele had distanced himself from these, he had, logically, to separate from Wally too. On the other hand, this self-aware friend and muse of the early years was seriously important for the artist's development and self-image.[15] Schiele created a monument to her and to the two of them in a double portrait in whose intimate style the Middle Ages and Modernism are combined (figs. 13, 14).

CARDINAL AND NUN/CARESS

A few months before the prison caesura, Schiele painted one of his most enigmatic pictures, *Cardinal and Nun* or *Caress* (fig. 15). Schiele had no interest whatever in a critical depiction of illegitimate relationships among ecclesiastical personnel. Rather, what we seem to have here is a sexual exchange, a "sexual travesty"[16]. Rudolf Leopold wrote of this picture:

12 *Autumn Tree in Movement ("Winter Tree")*, 1912
Oil on canvas, 80 × 80.5 cm
Leopold Museum, Vienna

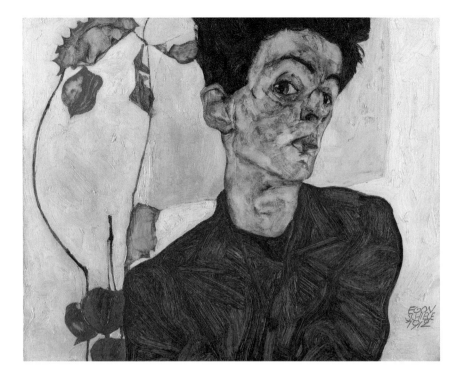

13 *Self-Portrait with Chinese Lantern Fruits*, 1912
Oil and body colour on wood, 32.2 × 39.8 cm
Leopold Museum, Vienna

14 *Portrait of Wally Neuzil*, 1912
Oil on wood, 32 × 39.8 cm
Leopold Museum, Vienna

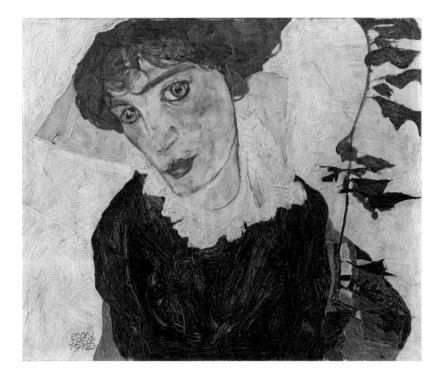

"Curiously, Schiele used a female model to study the pose of the cardinal figure": the calves and feet of the cardinal – or else of a further male figure kneeling behind him – were, he said, taken directly from watercolour studies for which Wally Neuzil sat as model (fig. 16). "Perhaps even more curious is the circumstance that the facial type of the nun is surprisingly similar to that which we find in Schiele's self-portrait."[17] (fig. 17)

However that may be, the cardinal himself is certainly not a self-portrait. His face is too mask-like, too wooden. Rather, we must see him as a depersonalised puppet: the unnaturally straight neck of the man symbolises the erect male member, just at it does in Gustav Klimt's famous painting *The Kiss*, of which the *Cardinal and Nun* is clearly a paraphrase.

Except that here the gender roles are reversed: the cardinal threatens the nun/Egon, who is erotically engaged, in an excess of orgiastic energy, with a man who has Wally's legs. The strong reds of the cardinal's robe – a red that is found in this intensity only in the works of Chaim Soutine – go

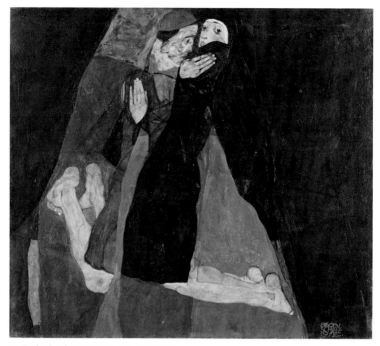

15 *Cardinal and Nun (Caress)*, 1912, oil on canvas
70 × 80.5 cm, Leopold Museum, Vienna

decidedly beyond a simple replication of an ecclesiastical garment, and, alongside the nun's deep black and her fearful expression, become the bearers of the picture's significance, which unites the ruthless urge on the one hand, and, on the other, the soul abandoned defenceless to this urge, namely the nun, or also the couple consisting of the nun and the hidden third figure.

As a child, I often sat looking at this picture. I was confused by the contrast between the emotionally scarred woman and the rigid facial expression of the man, which made it hard for me to understand what the picture was trying to tell me – had it not been for the strong, dominant impression created by the red and the black, and their immediate, albeit non-verbally comprehensible, formal entangling. That too was a contrast, but it triggered a clearly defined feeling. Psychologists call it "Lustangst" ("lust-fear") – the concurrence of an irresistible primal urge and the knowledge of the threatening consequences of yielding to it.

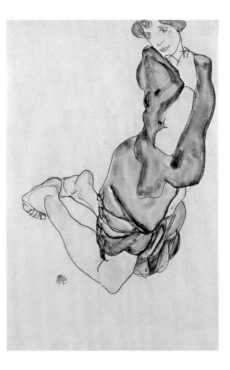

16 *Kneeling Woman with Grey Shawl
(Wally Neuzil)*, 1912, black chalk
Watercolour and gouache on paper
46 × 31.2 cm, Leopold Museum, Vienna

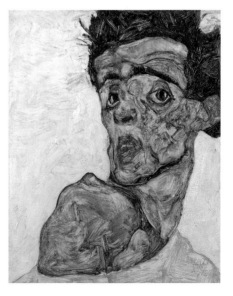

17 *Self-Portrait with Raised Bare
Shoulder*, 1912, oil on wood
42.5 × 34 cm, Leopold Museum, Vienna

Reformulated with the knowledge that comes with adulthood: the sexual-erotic event has a spiritual unconditionality symbolised by the elevated position of the cardinal in the hierarchy. The soul cannot avoid this process, even if it fears it. Both together, urge and sensitivity, are what characterise Egon Schiele as a person. The emotional balance is threatened, and yet there is no way past it. It is as though Schiele had foreseen the soon-to-ensue existential danger – the prosecution and imprisonment – that was triggered by this imbalance. On one of his prison watercolours shortly afterwards he wrote: "My wandering path leads across abysses"[18].

THE ENDANGERED IDENTITY

Schiele already drew as a child; this was the specific expression of his identity. And who reinforces, who protects, the identity of a child? Its parents, and to start with, of course, above all its mother (fig. 19).

For decades people have pointed to the ambivalent relationship between Schiele and his mother, to his constantly frustrating relationship with her – a psychological complex which is evidenced not only by pictures but also by letters and memories from the family circle. Gertrude, the younger sister, reported a key experience undergone by her brother: "The countless drawings that Egon made from the window of the dining room of the trains coming in and going out and the express trains that went straight through (...) right down to the last detail on long strips of paper with incredible dynamism passed one day through Mama's hand into the fire.

The destruction of the drawings – and, what is more, by precisely that person who should have been the guarantor of the child's survival – was like

18 *Train Racing Past*, 1906, pencil on paper, 23 × 10 cm
Leopold Museum, Vienna

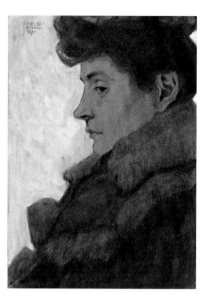

19 *Portrait of the Artist's Mother
(Marie Schiele) with Fur Collar*, 1907
Pencil, watercolour, gouache and
opaque white on paper, 32.1 × 22.5 cm
Leopold Museum, Vienna

the destruction of his self. An indication of how profoundly Schiele was traumatised by this event can be seen in the reaction to a situation in which again his existence was at stake, namely at the trial in April 1912. Schiele later reported that one of his drawings had been burnt in the courtroom.[19] This is however unlikely, for incriminating objects are always destroyed outside the court building. It is therefore plausible to assume that Schiele's story was a purely internal, emotionally triggered re-enactment of the original traumatic event.

Evidence that Schiele felt misunderstood, rejected and undervalued by his mother can be found time and again in the correspondence between the two. Likewise that Marie Schiele, for her part, knew of her son's ties to her and sought to take advantage of them.[20] Melanie Schuster, Schiele's eldest sister, once went as far as to say that her mother, after writing a particularly reproachful letter to Egon, "had remarked, full of satisfaction, "This letter went straight and devastatingly so to his heart!"[21]

On the other hand, this same woman got her way against the wishes of Leopold Czihaczek, Egon's uncle and legal guardian, by ensuring that her talented son was allowed to enrol at the Art Academy. The difficult thing about her was simply that it was impossible to judge unambiguously what kind of person she was. Only in this way could the ambivalent bond come about. It is in this context that we must also see Schiele's lifelong practice of drawing the nude.

SCHIELE'S NUDES

The young Schiele suffered from an exceedingly strong fascination with his own sexuality, and with that of others, particularly of adolescents. As I noted above, he later restricted this interest to adult women. He depicted himself in blatant fashion, as though acting under a compulsive spell. He showed young girls at the stage of their earliest sexual awakening. (fig. 20). It must be said in his defence that he made no secret of his treatment of this theme, and thus worked to dismantle senseless and inhumane taboos more than almost any other artist ever. It was this consciously seized artistic vocation, together with the regressive fixation of which he was partly conscious, and whose origins doubtless lay in his ambivalent ties with his mother, that gave his art that unique intensity that we link today with the name Schiele.[22]

Gerti, his younger sister, sat to her brother from an early age, sometimes fashionably dressed, sometimes nude (fig. 21) – the latter to the displeasure of their parents, who were unable to gauge how far things went. Her bodily forms are sometimes smoothed out to heighten the impression of beauty; the sensuous appeal is evident.

On one occasion Egon even took Gerti on a train journey to Trieste, where they stayed in the same hotel, maybe even the same room, as their parents

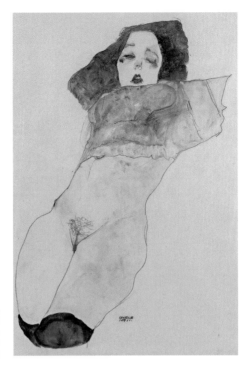

20 *Girl with Bared Abdomen,*
1911, pencil, watercolour
and gouache on paper
53.7 × 35.8 cm
Leopold Museum, Vienna

had once stayed, in order to re-enact their honeymoon … That Gerti in this case became a scarcely disguised transfer image of their mother must have been clear to both of them.

Schiele certainly intended to provoke his family, too, with his artistic programme of representing taboo-free sexuality, be it his own or that of his young models. This is shown by the choice of places in which he executed his nude studies in extremis: first in Český Krumlov on the River Vltava (then known as Krumau an der Moldau, now in the Czech Republic), his mother's birthplace. And later on in Neulengbach, in the Vienna Woods, where his uncle and guardian owned a country cottage. It was in these of all places that Schiele went so far in his uninhibited dealings with models and adolescents that he was sent packing and almost totally ostracised from polite society.

At the same time, however, it was during these very years – 1910, 1911 and early 1912 – that Schiele achieved artistic uniqueness and mastery. For the

inner tensions and obsessive stimuli were essential for the development of his art. He not only accepted that this went hand in hand with a breach of conventional taboos – a breach that could not have been more blatant – but insisted on it as though his survival were at stake. He did it so radically and intensely that some of his works still offend people's moral feelings. But for the same reasons, this early work exerted an immense influence on generations of artists, as it still does.

On the other hand – and this needs to be remembered, or else our understanding of this artist will be one-sided – Schiele did seek to shake off these obsessions. For he evidently understood that if he remained in the rut of sexual fixation, his art would ultimately fossilise into a certain one-dimensionality, and hence become atrophied. He himself thus represented the exuberance of his taboo breaches far more carefully than some of the later flag-wavers: "Sure, I've done pictures which are 'frightful', I won't deny it. But does anyone think I liked to do this, and only in order to provoke the stuffed-shirt brigade? No! That was never the case. But yearning draws forth its spectres. I painted such spectres. Certainly not for my pleasure, it was a must."[23]

ASCETIC PICTURES

Schiele painted himself in those years as haggard and cadaverous – as he probably was. The precarious social situation seemed to suck the lifeblood from him and his models, and this was perhaps reinforced by the sexual obsession. At the same time the many cadaverous self-portraits always have an ascetic component too.

In the large yellow nude (fig. 22) he depicts himself reduced to pure energy of will, reminiscent of the self-creation fantasies of earlier pictorial experiments. Never has there been painted a so concentratedly tense, autopoietic monument to the self. Schiele is often identified by artists with this one picture alone.

As a child, I was always somewhat embarrassed by this image, firstly because of the self-presentation as a nude, and secondly because of the incomprehensible pathos. As a child, I found it tragicomical that anyone could behave thus. And yet I could never laugh at it. For the clearly defined, easy-to-see tension of muscles and sinews, magnificently staged,

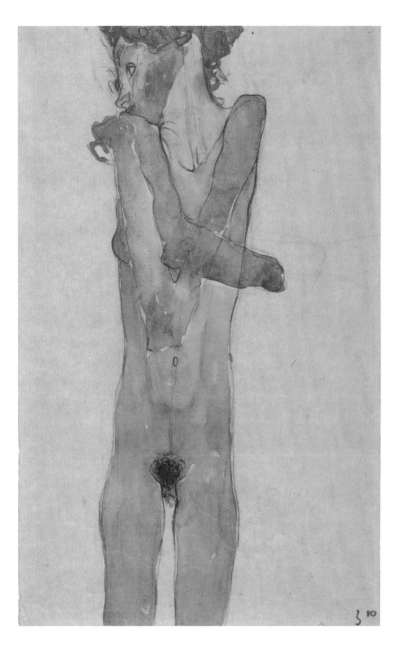

21 *Nude Girl with Folded Arms (Gertrude Schiele)*, 1910, black chalk and
watercolour on brown paper, 44.6 × 27.8 cm, Albertina, Vienna

was (and is) simply too stark as a phenomenon. And this is doubtless the theme of the picture: a maximum, deliberate tension, which, so to speak, redoubles the abandonment to bodily existence, and in so doing overcomes it. If ever an existentialist picture was painted, this is it. Sartre's word that man was "condemned to freedom" has here become flesh.

As I said, for a child who accepts his own body in a natural fashion, such demeanour is frightening. As a secret mitigation of the spell that this picture always cast on me when I saw it, decades later in the Leopold Museum, I hung the formally related small-format picture of a little tree next to it: what in the one picture reflects tension to the extent that it seems that the body is being literally "tested to breaking-point"[24], is, in the juxtaposition, resolved into a delightful dance of existence (fig. 23).

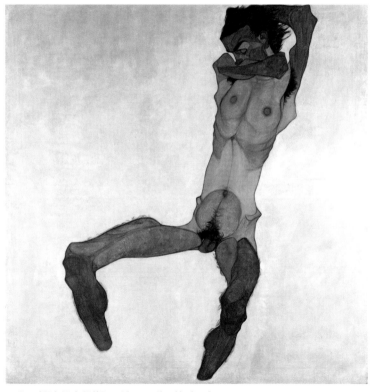

22 *Seated Male Nude (Self-Portrait)*, 1910, oil and body colour on canvas
152.5 × 150 cm, Leopold Museum, Vienna

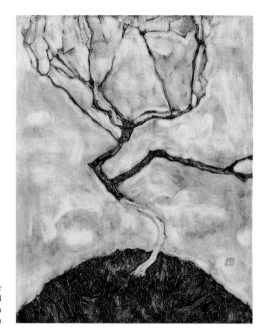

23 *Small Tree in Late Autumn*, 1911, oil on wood
42 × 33.5 cm
Leopold Museum, Vienna

The large painting *Levitation (Wafting Away)* (fig. 24), dating from a few years later, depicts the reverse side of this coin. The highly tuned tension has given way to total relaxation, the insistence on the ego has yielded to a *laisser-aller*. What we see are two dead men, and again, both figures are self-portraits. They have become lighter than air and are wafting away into the ether above a world-meadow in autumn colours.

The First World War had already begun. The artist is revealed as a seismograph of his age, although, or precisely because, he has arrived at his archetypal pictorial ideas entirely from within himself. But this is no mere commentary; rather, the artist is, in this picture, giving his age a lesson to which it will pay no attention: for in difficult times the values of inwardness are lost.

As in the lost painting *Resurrection*, the lower of the two figures has his eyes wide open. At the same time, his gaze is directed both inward and outward. He is, in a spiritual sense, "blind" to the trivial everyday world – Schiele also called the painting *The Blind*. He sees the essentials behind the world, by seeing inside himself at the same time. By contrast, the eyes of

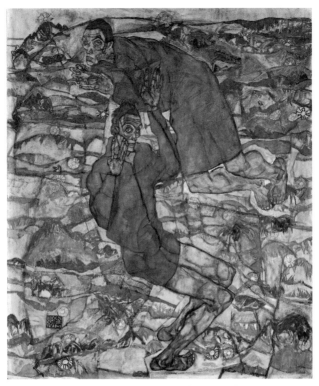

24 *Levitation (Wafting Away; The Blind, II)*, 1915, oil and body colour on canvas
200 × 172 cm, Leopold Museum, Vienna

the man above seem broken. He is in a hopeless state of material evacuation, hovering with cramped fingers over the meadow, and dissolving.

Not all interpreters see both figures as rising into the air. The lower one is sometimes seen as descending to earth.[25] In the picture, this may yet be undecided, but in his life, Schiele had already decided. And only for this reason could he validly depict the state of oscillation between a final farewell and a determined arrival in a world which was to be different from the one hitherto.

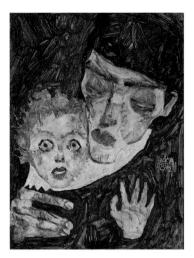

25 *Mother and Child,* 1912, oil on wood
36.5 × 29.2 cm, Leopold Museum, Vienna

MOTHER PICTURES/PICTURES OF HOUSES

Whence comes the necessity of leave-taking qua death-in-life and arrival
in the altogether-elsewhere? Schiele formulated the absent – and spiri-
tually sought-after – primal existential trust in a series of pictures of
mothers, for example *Mother and Child,* 1912 (fig. 25), *Mother and Daughter,*
1913 (fig. 26), *Blind Mother,* 1914 and *Mother with Two Children,* 1915, to
name but the most important. The prototype is *Dead Mother* dating from
1910 (fig. 27).

Arthur Roessler claims to have advised his artist friend to transfer his ten-
sions directly on to the canvas, to "transform suffering into an artwork".[26]
Dead Mother is the surreal image of a mind clinging desperately to life
while the ground is being swept away from beneath its feet.

A comparison of the early picture with the thematically related later ones
shows up the difference between Schiele's earlier, most expressive phase
from 1910 to early 1912, and the quieter period that followed his imprison-
ment and lasted until about 1915. In the 1910 picture we see a newborn
child being held by a dead mother in her black garment. The child is rosy
and fleshy, profoundly alive, but totally helpless. It will not be able to
escape encirclement by the dead maternal aspect, sensitively though this is
depicted. The unbridgeable contrast between the little being and the

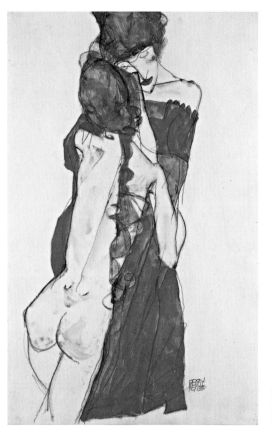

26 *Mother and Daughter,*
1913, pencil, gouache
on paper, 47.9 × 31.1 cm
Leopold Museum, Vienna

emaciated, stone-cold woman, between the warm flesh tones and the
graphic areas in black and olive, is painfully touching.

In the later pictures of mothers, on the other hand, the total situation is de-
picted in a manner which stylistically unifies all components of the painting;
in other words, the human drama takes place within an analogous context.
As a result, the emotional effect is somewhat reduced. The existential event
clots into archetypal images, the meaning – blind lethality, unconscious
sacrifice on the altar of the mother goddess – clearly formulated, while in
the early picture an as yet unresolved conflict is taking place.

In the series of house-scapes we can see an analogous development from
existential immediacy to all-embracing pictorial invention. On the early

picture of this genre, *Dead Town* (fig. 28), a piled-up mass of houses, nested into each other, rises up without any motivation out of the void of a black river – empty, absurd, a fossil which nonetheless testifies to an absurd will-to-life hidden in the tense formal structure.

By contrast, the row of houses in a later picture, *Houses by the Sea* (fig. 29), is placed in a broad landscape. These empty houses are part of an eschato-logical landscape. Their total atmosphere is one of melancholy.

This painting always disturbed me. As a child, I found the colours of the houses revolting, like rotting flesh. Schiele here convincingly combines feelings of transience and futility with the highest stylistic art: the linear structure is in unnatural multiple perspective; the houses seem to be alive, their mask-like "faces" a grim *danse macabre*.

Apart from the uniquely delicate style of these housescapes, some of them, in fact the best, seem to be also capable of psychological interpretation, for example *Houses with Washing* (fig. 30):

In the foreground a colourful childhood world spreads out before us. In the middle ground, symbolised by the houses, lies the rigid, dehumanised

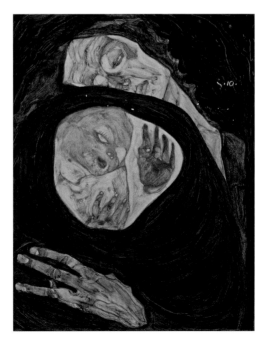

27 *Dead Mother I*, 1910
Oil and pencil on wood
32.1 × 25.7 cm
Leopold Museum, Vienna

world of the mothers, while behind, above the clouds, there stretches an idealised vista of inaccessible mountain peaks – the realm of the dead father?

As a child I could always relax with the bright colours in the foreground, while at the same time I was disconcerted by the comprehensive emptiness. Even as an adult, Schiele liked to play with children's toys for hours on end – escape from a hostile world or a link to the creative reservoir?[27] And once again, in a seismological coincidence, the historical geopolitical situation matched the inner state of the artist. The attempted solution, a return to childhood, to unworldly aestheticism, exemplified for instance by Hugo von Hofmannsthal, turned out to be fragile, the reflexion on higher values an illusion. What was to remain, by 1918, were nostalgic memories, devoid of substance, of a dilapidated empire, the Austro-Hungarian monarchy.

MELANCHOLY

Following his stay in prison, Schiele constantly wrote in his letters that he was now no longer doing anything "immoral", and that he had become more "manly" in the meantime. He also complained that his dealings with his mother were unhealthy for his emotional equilibrium.[28] By contrast, he

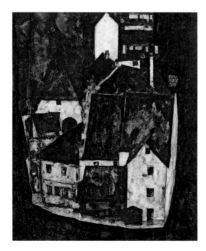

28 *Dead Town III (Town on Blue River, III)*, 1911, oil and body colour on wood, 37.3 × 29.8 cm Leopold Museum, Vienna

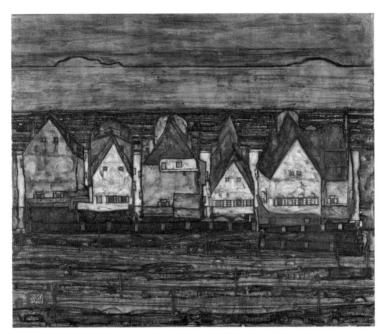

29 *Houses by the Sea (Row of Houses)*, 1914, oil on canvas
99.5 × 119.7 cm, Leopold Museum, Vienna

seemed to regard the "fusion" with the paternal as necessary in order to grow up.

His father had died in a state of mental confusion when Egon was 14 years old. Schiele idealised him, doubtless in order to cope with his premature death. A kind of medium with which to maintain contact with the father he missed, was the feeling of grief, the hermeneutic of melancholy.[29]

Schiele used this mood in order to connect to the invisible, but intensely experienced, personal world that he himself had created and which he regarded as the more real. At the same time, he detached himself from the more banal world of his mother and his guardian uncle.

In addition, Schiele spoke of meetings with the spirit of his late father: "I really did experience a beautiful spiritualist case today; I was awake, but under the spell of the spirit that announced itself in a dream before I woke up; all the time it was speaking to me, I was rigid and speechless." And in the same letter, his friend Anton Peschka added: "Egon keeps talking in

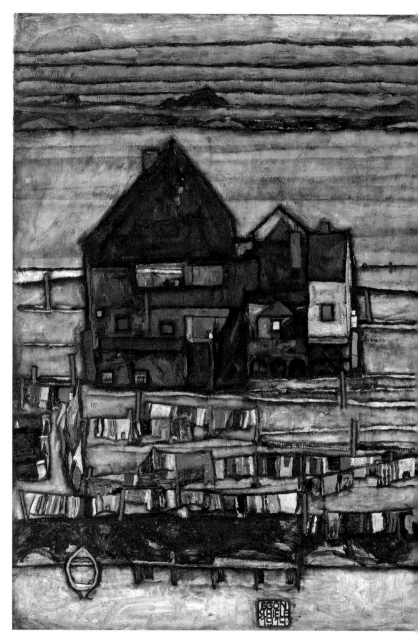

30 *Houses with Washing (Suburb, II)*, 1914, oil on canvas, 100 × 120.7 cm, private collection
(until June 2011 Leopold Museum, Vienna, inv. no. 528), Photo: Leopold Museum, Vienna

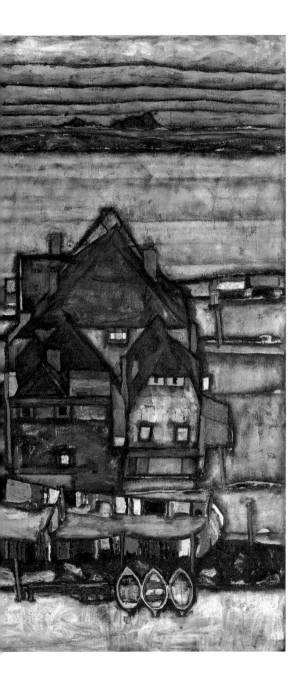

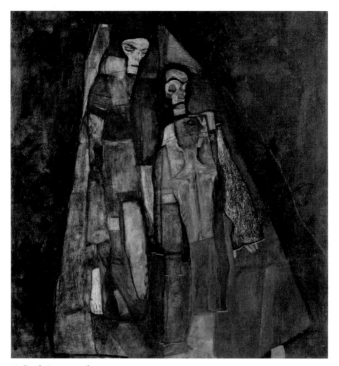

31 *Revelation*, 1911, oil on canvas
90 × 84.5 cm, Leopold Museum, Vienna

the night, last night he said his papa had been with him, and it really wasn't
in a dream – he spoke to him at length!"[30]
In this dark-hued, "Gothic" world, which mystically transcended his per-
son, he also had a counterbalance to his narcissistic, obsessive downside.
In a way, Schiele was, as a result, his own, rather skilled therapist. The
"melancholic method" stopped him from becoming ossified as an un-
worldly aesthete and self-pitying provocateur, and as the epigone of him-
self, as happens to many other artists.

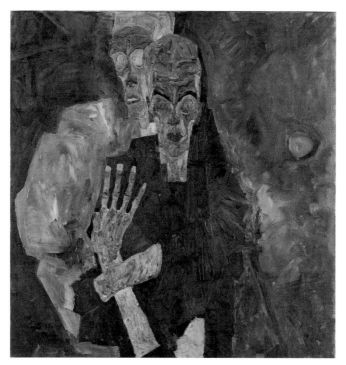

32 *Self-Seer II (Death and Man)*, 1911, oil on canvas
80.5 × 80 cm, Leopold Museum, Vienna

REVELATION

In the description, which Schiele included in a letter, of the painting
Revelation (fig. 31), we find the psychological integration of the paternal-
masculine in a highly symbolic fashion. There is no lack of clarity in what
he says:
"Have you ever felt what kind of impression a great personality exerts on
the world around him? (…) The one half is then intended to portray the
vision of a man so great that the one thus influenced and captivated kneels
down, bows down before the greatness which sees without opening its
eyes, which decays, and from which the astral light emanates orange or in
other colours, in such excess that the one bowing down flows, hypnotised,
into the great one. (…) What I mean is that the small kneeling figure melts
into the radiant great one."[31] (see p. 76f.).

Admittedly, we must not reduce a painting of such spiritual intention entirely to personal psychology. Painted in the manner of a church window, it draws – as it does the boy in the picture – the "captivated", indeed "hypnotised" beholder into the dark, mystic colours and through the triangular composition (one of Schiele's hallmarks) up to the "great one". The content, form and impression create a perfect unity. It is clear that such a picture is intended not merely as a visual bearer of information. It is, rather, primarily a magical object.

To this extent, in depth-psychological terms, it is still on the side of the as-yet-unachieved, but at least aimed-at integration of the masculine. It is an aid on the personal path, a catalyst of the individuation process. Precisely for this reason it does not yet represent the reality to be attained, which will be very much more sober. Which does not in any way detract from the quality of the artwork – on the contrary!

SELF-SEER

Another important painting that depicts union with the fatherly archetype is the mysterious *Self-Seer II* (fig. 32). With admirable clarity, Schiele has depicted a process that profoundly changes his identity under the aspect of the threat to the existing self-image, but at the same time pointed to the iridescent sphere of the semi-conscious within which such processes take place.

That Schiele did not just naively abandon himself to spiritualist episodes but also reflected upon them is shown by the complex arrangement of the painting, which resembles a cabinet of mirrors. We see more than just two people; on the right-hand edge a huge head can be made out, and it is unclear whose hand is looming up from below in the foreground. The reflections overstep the confines of the picture, spilling over as it were into the space of the beholders, who feel themselves drawn by the medium of this magical picture into a similar field of consciousness.

Confluence with the supernatural makes whoever is susceptible to it into a medium. Schiele's painted his self-portrait in the foreground, abstracted to the point of eeriness, like a ritual mask, which, as we know, blurs the boundary between life and death, between the visible and invisible worlds. To become a mask-wearer is a threat and an empowerment at the same time. The figure of death lurking behind[32], a second, even more strongly

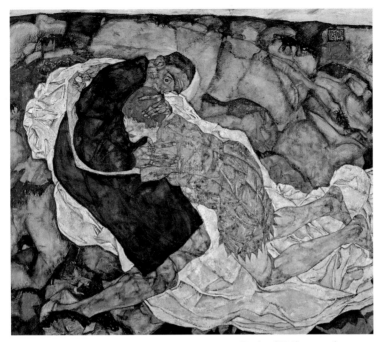

33 *Death and Maiden*, 1915, oil on canvas
150 × 180 cm, Belvedere, Vienna

abstracting self-portrait, grasping the concentrating first figure from behind, is evidently overwhelming the smaller, isolated ego and at the same time, as a result, emphasises a self which, as the picture's title says, consists of both together, the reflected and the reflector: "Self-Seer" – a highly complex artwork, both thematically and formally.

DEATH AND THE MAIDEN

In the early years, the personality component associated with death was still dressed up in Symbolist garb. At the biographical frontier, however, where Schiele took leave of earlier fixations and entered into a mature relationship based on equal rights, he composed a picture somewhere between magical Symbolism and expressive narration: *Death and Maiden*, 1915 (fig. 33).

34 *Embrace (Loving Couple II)*, 1917, oil on canvas
100 × 170.2 cm, Belvedere, Vienna

Evidently the artist recognised himself here as "fatal" for the dying rela-
tionship with his lover Wally Neuzil. He thus no longer needed any sym-
bol: his face, and Wally's, are clearly recognisable. Schiele paints "Death"
as a self-portrait, and this "real" man looks on helplessly, and as it were
paralysed by shock, at the event which he has brought about. Not only
Wally, whom he will abandon and who still clings helplessly to him, will
"die"; he too will have to pass through his own death, or rather: through

himself as "Death" – a psychologically clear-sighted depiction, which, even more importantly, is also artistically convincing. For the composition, the arrangement of the figures: their turning-in towards each other and, at the same time their already apparent inward drifting apart, gently but firmly draws into its clutches all those who expose themselves to this picture for longer than the well-known three seconds reported by museum visitor statistics.

ENCOUNTER AND FAREWELL

One of Schiele's last Symbolist works, and one which he left unfinished, is the picture *Encounter* (see p. 67, fig. 46). It is now only known from a black-and-white photograph in which the artist is seen posing in front of it. With this picture, Schiele had painted a new and unique kind of artwork. "The meeting that Schiele stages in front of Anton Trcka's camera points to a pre-symbolic relationship to the artwork, such as we see expressed in the cultic veneration of objects,' writes Doris Krystof, who speaks of a "bodily and material contact far removed from all linguistic conventions".[33]

The young man in the painting is turned towards the beholder; whether to take his leave or as an invitation to do the same in return, remains open. It looks as though he were about to turn round any moment to the holy man behind him and continue the succession. Here, this "saint" no longer symbolises "death" as in earlier paintings, but evidently an idealised, larger self. Schiele for his part is placing a finger against the garment, on the saint's backbone, taking up contact with him. His eyes are not closed; rather he is gazing into the indefinite distance. He depicts an inner process as having been concluded, a process through which he has overcome Symbolism with the underlying fixations.

It therefore seems only logical that he never completed this highly symbolic picture. With it, he was leaving behind the early phase, which today seems to us to have been the most valuable in his œuvre.

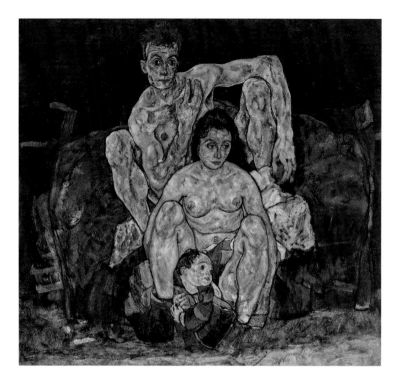

THE SEARCH GOES ON

Schiele subsequently began to seek a new artistic identity. As a human being, he had clearly arrived on this earth intact; as an artist he was searching once again. Pictures were painted that are quietly beautiful, but in which we miss the earlier tensions of colour and composition.[34] (fig. 34) We see in the portraits that he now painted that his gaze was being directed more sensitively outwards, to the capturing of other people. This goes hand-in-hand, as we can see in the look on the face of the man in the picture *The Family* (fig. 35), with a certain disillusionment, possibly even resignation.

"The war is over and I have to go." These were supposedly Schiele's last words.[35] Was he unconsciously referring to his own inner conflicts? One of his last unfinished pictures, *Loving Couple*, 1918 (fig. 36), shows him sober and clear-headed, but still full of palpable feeling for the inward, and above all for the bisexual one-in-twoness, for the "dividuum"[36]. In this sense he was

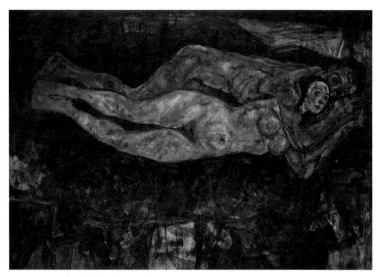

36 *Loving Couple*, unfinished, 1918, oil on canvas
155 × 210 cm, Leopold private collection

still, right at the end, open to the new, and, just as at the beginning, the precursor and role model for artistic developments that happened much later.

DIETHARD LEOPOLD *(b. 1956) is the son of the art collector Rudolf Leopold. He studied German Studies, Theology and Psychology at the University of Vienna and worked as a psychotherapist (Gestalt Therapy) in Vienna. Since 2008 he has been the curator of the Leopold Museum there. As well as curating numerous exhibitions he has published books and catalogue contributions, especially on the subject of "Art and Culture in Vienna around 1900".*

1 This form of perception also exists among adults – the famous art historian Aby Warburg, for example, who "regarded a picture as an active, rather than a representative, object, which was certainly in a position to do something to the viewer." Cf. Pablo Schneider: "Die Zivilisation vorantreiben – Bilder, Motivwanderungen und Humanitätsidee im Denken Aby Warburgs", in: Aby Warburg: *Nachhall der Antike*, diaphanes, Zürich 2012, p. 105.
2 Nebehay, Christian M., *Egon Schiele 1890-1918 – Leben Briefe Gedichte*, Salzburg and Vienna, Residenz Verlag, 1979, pp. 163f.
3 Letter c. 1910 to Anton Peschka, in: Elisabeth Leopold (ed.), *Der Lyriker Egon Schiele. Briefe und Gedichte 1910-1912 aus der Sammlung Leopold.* Munich, Prestel Verlag, 2008, pp. 13–15.

4 Nebehay, 1979, op. cit., pp. 214f.
5 Leopold, Rudolf, *Egon Schiele – Gemälde Aquarelle Zeichnungen*, Salzburg and Vienna, Residenz Verlag, 1972, p. 212.
6 Nebehay 1979, op. cit., pp. 214f.
7 Leopold 1972, op. cit., p. 212.
8 Ambrózy, Johann Thomas, 'Das Geheimnis der "Eremiten"', in: *Egon Schiele Jahrbuch*/2011, pp. 10–57.
9 See Wischin, Franz, 'Ich Gefangener, schuldlos gestraft, gereinigt!' – *Kunst oder Kinderporno-graphie: Die Affäre von Neulengbach 1912*, Vienna and Munich, Christian Brandstätter Verlag, 1998. – See also Ernst Ploil, "Bestraft für seine Kunst – Egon Schieles Prozess – von Mythen befreit", in: *Parnass*, 3/2006, pp. 116–119.
10 Nebehay 1979, op. cit., p. 228.
11 Ibid., p. 198.
12 Cf. C. G. Jung, "Psychologie und Alchemie", in: *Gesammelte Werke*, vol 12, Solothurn and Düsseldorf, Walter-Verlag, 1995. See e.g. p. 473, fig. 226.
13 Here the reference is to a term "Dividuum" coined by Stefan Bertschi with reference to Peter Sloterdijk's "spheres" philosophy. In Stefan Bertschi, *Im Dazwischen von Individuum und Gesell-schaft – Topologie eines blinden Flecks der Soziologie*, Bielefeld, transcript Verlag, 2010, p. 291.
14 Summerauer, Birgit: "Wally Neuzil. Viele Grüße von der Klapperschlange – Die Gefährtin Egon Schieles", in: *Wally Neuzil – Ihr Leben mit Egon Schiele*, ed. by Diethard Leopold, Stephan Pumberger and Birgit Summerauer, Vienna, Brandstätter Verlag, 2015 pp. 95–96.
15 See Diethard Leopold "Orpheus & Orphea – Maler & Modell", in Leopold et al. 2015 (see note 13), pp. 106–129.
16 Leopold, Diethard: "Egon Schieles Psychotechnik – Provokation und Melancholie als Medien der Selbstheilung", in: Elisabeth and Diethard Leopold (eds.): *Egon Schiele – Melancholie und Provo-kation*, Vienna, Brandstätter Verlag, 2011, pp. 48–65. – English: "Egon Schiele's Psychotechnique – Provocation and Melancholia as Methods of Self-Healing", in: Elisabeth and Diethard Leopold (eds.): *Egon Schiele – Melancholy and Provocation*, Vienna, Brandstätter Verlag, 2011, pp. 48–65. – See also Diethard Leopold: "In and Out of the Prison of One's Self: Provocation and Melancholia as Artistic Methods in the Life and Work of Egon Schiele", in: Alessandra Comini (ed.): *EGON SCHIELE – Portraits*, New York et. al., Prestel, 2014, pp. 115–139
17 Rudolf Leopold 1972, op. cit., p. 228.
18 Gouache and watercolour, 27.IV.12. Albertina, inv. no. 31.026, Kallir D 1191.
19 Nebehay 1979, op. cit., p. 222.
20 See e.g. Nebehay 1979, op. cit., pp. 263 and 266.
21 Quoted from Leopold 1972, op. cit., p. 13.
22 On the psychological analysis of Schiele's life and the development of his art, see Diethard Leopold 2011, op. cit., and from a psychoanalytical perspective Danielle Knafo, *Egon Schiele – A Self in Creation*, London and Toronto, Associated University Press, 1993.
23 Roessler, Arthur, *Erinnerungen an Egon Schiele*, Vienna, 1948, p. 40. – Although there must be a suspicion that Roessler invented the formulation himself, the content does fit well with Schiele's efforts, as documented in his letters, to develop his personality further.
24 In German "Zerreißprobe" – Title of the last action by Günter Brus, who always appreciated Schiele and in particular this painting.
25 Comini, Alessandra: *Egon Schiele's Portraits*, Berkeley, University of California Press, 1974, pp. 142f.
26 Quoted from Leopold 1972, op. cit., p. 557.
27 Cf. C. G. Jung's return to the toys of his childhood in a period of deep crisis. In: C. G. Jung, *Erinnerungen, Träume, Gedanken*, recorded and edited by Aniela Jaffé, Walter Verlag 1961, no location, n.p.
28 See e.g. Schiele's letter to his mother dated 31 March 1913, in: Nebehay, 1979, op. cit., p. 252.
29 See Diethard Leopold 2011, op. cit.
30 Letter from Anton Peschka to Gertrude Schiele (his future wife) dated 25 August 1910. Nebehay, op. cit. 1979, p. 134.
31 Letter from Schiele to Hermann Engel in September 1912. Nebehay, op. cit., 1979, p. 228.
32 Schiele also called the painting *Tod und Mann* ("Death and Man").
33 Krystof, Doris: "Gescheiterte Begegnung – Schieles unvollendetes Wandbild von 1913 und die Krise der Ikonographie", in: Pia Müller-Tamm (ed.): *Egon Schiele – Inszenierung und Identität*, Cologne, DuMont Buchverlag, 1995, p. 98. – Cf. also Comini, op. cit., 1974, pp. 108f. and 133.
34 Leopold,1972, op. cit., pp. 422–425.
35 Leopold 1972, op. cit., p. 17.
36 See note 12.

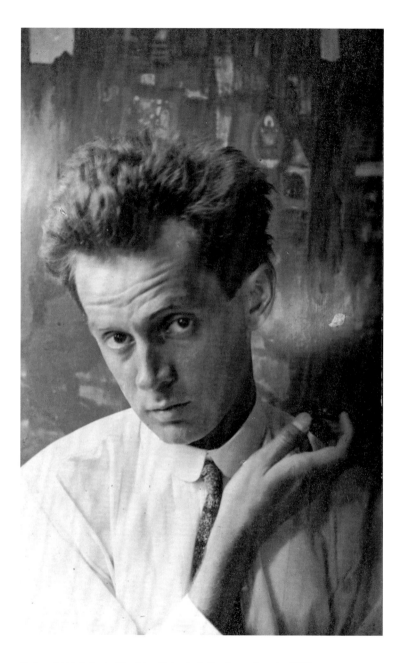

37 Egon Schiele in front of the picture *Shrines in the Forest*, 1915, photo: Josef Müller

BIOGRAPHY

Egon Schiele
1890 – 1918

1890 Egon Leo Adolf Ludwig Schiele is born on 12 June in Tulln, a small town in Lower Austria. He is the third child of an official of the Austro-Hungarian Royal and Imperial railway, Adolf Eugen Schiele (1850–1904) and his wife Marie Schiele, née Soukup (1862–1935). The father is station master in Tulln and lives with the family in an official apartment on the top floor of the station. Egon grows up in a lower-middle-class household with his sisters Melanie (1886–1974) and Gertrude (1894–1981), the eldest sister Elvira (1883–1893) having died of meningitis as a child. Schiele develops a particularly close relationship with Gertrude ("Gerti"), who will often sit to him as a model during his early phase as an artist.

1896–1904 Egon Schiele first attends the elementary school in Tulln, and from 1901 the "Realgymnasium" (non-classical grammar school) in Krems, where he lives with relations. In the autumn of 1902, not doing well at school, he changes to another in Klosterneuburg. Even while at elementary school he begins to draw (see fig. 18) and often continues this during lessons at high school, giving rise to complaints from teachers.

Egon's father's health is not robust, and becomes steadily worse, so that in 1902 he is put on permanent sick leave. As his health deteriorates, his mental confusion increases. In 1904 the family moves out of the station apartment in Tulln to Ortnergasse 28 in Klosterneuburg, where Adolf Schiele dies on 31 December 1904, probably of "progressive paralysis". 14-year-old Egon is greatly affected by the death of his father; he links this period with "serious emotional suffering".

1905–1906 Egon's uncle and godfather Leopold Czihaczek (1842–1929) is appointed his guardian; he is a prosperous Viennese engineer, married to a sister of Egon's father. While at school in Klosterneuburg, Egon makes friends with his drawing teacher Ludwig Karl Strauch, who gives him private lessons in landscape and portrait painting and allows him to use his studio. He also gets to know the painters Max Kahrer and Adolf Böhm. 1905 sees his first self-portrait, and by 1906 he has executed numerous landscapes.

After Schiele has been put down a class for a second time as a result of poor performance, his wish to embark on an artistic career is supported by some of his teachers and by his mother. His guardian, who originally wanted him to study at the Technical College in Vienna, finally also agrees, and will provide him with financial support for a while.

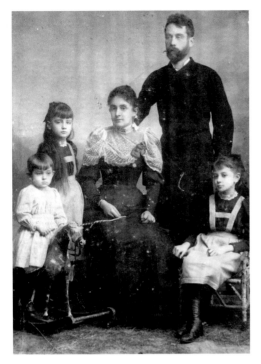

Schiele's parents with Egon, Melanie and Elvira, 1893

39 Egon Schiele with palette,
September 1906,
Leopold private collection

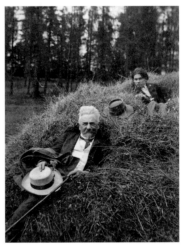

40 Egon Schiele with his uncle Leopold
Czihaczek in Neulengbach, sitting in the hay,
1908, Leopold private collection

In October 1906 Schiele passes the entrance examination for the Academy of Visual Arts in Vienna and begins to study art; at 16 he is the youngest student. He joins the general painting class of Christian Griepenkerl, the chief exponent of Viennese Ringstrasse painting, under whom Strauch had also studied.

1907–1908 Together with his family Schiele moves to Vienna. Here he meets Gustav Klimt, who acquires an important position as his artistic role model. With his younger sister Gertrude, Schiele travels to Trieste and makes a number of studies of harbour motifs.

Schiele moves into the first studio of his own in Kurzbauergasse 6, in Vienna's 2nd district. From May to June 1908, he takes part for the first time in a public exhibition, where he shows ten works. At the presentation in the Augustinian Priory in Klosterneuburg, he catches the eye of Heinrich Benesch, later one of his most important collectors and followers.

1909 At the *Internationale Kunstschau 1909*, whose exhibition committee is chaired by Gustav Klimt, four works by Egon Schiele are shown alongside works by Vincent van Gogh, Edvard Munch, Henri Matisse, Pierre Bonnard, Paul Gauguin, Jan Toorop, Oskar Kokoschka and George Minne. In protest against the old-fashioned teaching methods and curricula, Schiele discontinues his studies in April and leaves the Academy. Together with like-minded people such as Anton Peschka, Anton Faistauer, Franz Wiegele, Rudolf Kalvach, Erwin Dominik Osen and the composer Arthur Löwenstein, he founds the 15-strong "Neukunstgruppe" ("New Art Group"), whose president and secretary he becomes, also writing its manifesto. In 1911 Oskar Kokoschka, Albert Paris Gütersloh and Karl Hofer, among others, also join. In December the group holds its first exhibition in Vienna, at the salon of the art dealer Gustav Pisko. Here Schiele meets important collectors: the art writer and critic of the *Arbeiter-Zeitung* Arthur Roessler; the industrialist Carl Reininghaus; the Viennese physician Dr Oskar Reichel; and the publisher Eduard Kosmack.

Schiele makes friends with the painter Max Oppenheimer. In 1909/10, inspired by works of Rainer Maria Rilke and Arthur Rimbaud, he writes a series of Expressionist poems in prose form.

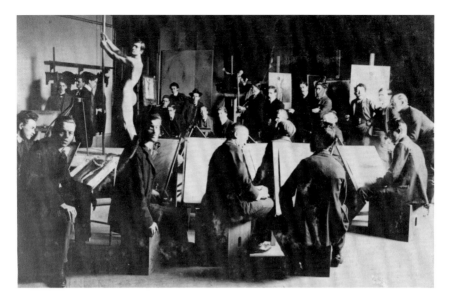

41 Life classroom at the Akademie der bildenden Künste in Vienna,
Egon Schiele is on the left in the background next to the man with a hat,
c. 1907, Leopold private collection, photo: Anonymous

42 Gerti Schiele in front
of the mirror in Egon Schiele's
studio, c. 1910

1910 Schiele's works are exhibited for a second time at the Augustinian Priory. The Wiener Werkstätte publishes three cards illustrated by him. Through the good offices of Josef Hoffmann, the head of the institution, whom Schiele had met in 1909, he participates in the *Internationale Jagd-ausstellung* (International Hunting Exhibition) in Vienna, where a life-size seated female nude by him is shown (present whereabouts unknown). When visiting the show, Emperor Franz Joseph is said to have found Schiele's work "quite appalling".

In mid-May Schiele goes with Peschka and Osen to Krumau, now Český Krumlov, the town in Bohemia where his mother was born, in order to set up an artist colony. When he telegraphs his uncle with a blunt request for money, the latter reacts with annoyance by renouncing his guardianship, so that from June Schiele has to stand entirely on his own feet financially. Schiele returns to Vienna and moves into a studio at Alserbachstrasse 39 in the 9th district, transferring a little later to another in the 12th district, at Grünbergstrasse 31.

1911 In April and May, the Galerie Miethke in Vienna plays host to Schiele's first major solo exhibition, but it meets with modest success. Schiele meets Walburga Neuzil ("Wally"; 1894–1917). She remains his favourite model and lover until he marries Edith Harms in 1915. In May, Egon and Wally move to Český Krumlov, where a highly productive artistic period starts for Schiele. The town's old quarter inspires him to paint a number of visionary townscapes. In the small-town atmosphere their un-married co-habitation soon arouses hostility, as does the fact that Schiele sometimes draws nude studies of very young girls. The couple leave Český Krumlov, and after a brief stay with his mother in Vienna, Schiele settles in Neulengbach, a small town near the capital, where Wally visits him often. After an unsuccessful attempt to make his peace with his former guardian, Schiele finds himself once more in financial straits.

Roessler introduces Schiele to the Munich art dealer Hans Goltz, who is to represent him for several years and find him further exhibitions in Germany. In November Schiele is admitted to the Munich artists' association Sema, whose members include Alfred Kubin and Paul Klee.

1912 Together with the Neukunstgruppe, Schiele exhibits in Budapest. In Munich his works are shown at exhibitions of the Secession and together with works by the "Blauer Reiter" artist group in the Galerie Hans Goltz. Goltz introduces Schiele to Karl Ernst Osthaus, the museum founder and chairman of the Sonderbund artists' association, which stages a prestigious show at the Museum Folkwang in Hagen, where pictures by Schiele are among those on display. In the spring, Schiele is represented at an exhibition held by the Vienna Hagenbund with seven oil paintings, including the *Hermits* (fig. 2). In the so-called Sema Portfolio, Schiele's first print appears, a lithograph of a nude self-portrait.

On 13 April Schiele is detained by the district court in Neulengbach, and on 30 April he is transferred to the court in St. Pölten. The background to his arrest is the official complaint by a father whose under-age daughter had run away from home and been taken in by Schiele and Wally Neuzil. Schiele is acquitted on the main charge of "violating a minor", but is convicted of "infringing public morals" (specifically, allowing public accessibility to some of his nude studies) and sentenced to three days' imprisonment. Together with the time spent on remand, Schiele spends a total of 24 days in custody, before being released on 7 May. While in prison he makes 13 watercolour drawings.

In the summer Schiele travels to Carinthia, Trieste, Munich, Lindau and Bregenz. Three of his works are exhibited at the international *Sonderbund* exhibition from May to September in Cologne, one of the most important shows of the pre-war period.

In November he rents a studio at Hietzinger Hauptstrasse 101 in Vienna's 13th district. He will use it until his death. Gustav Klimt introduces Schiele to the industrialist August Lederer, who becomes one of his most important collectors. This improves his financial position somewhat.

1913 Schiele becomes a member of the Bund Österreichischer Künstler (League of Austrian Artists), whose president is Gustav Klimt. Galerie Goltz devotes a major solo exhibition to Schiele in June and July. His works are also represented at the *Grosse Deutsche Kunstausstellung* (Grand German Art Exhibition) in Berlin and Düsseldorf, at the *Internationale Schwarz-Weiss-Ausstellung* (International Black-and-White Exhibition), and at the 43rd exhibition of the Vienna Secession. He becomes a contributor to the Berlin periodical *Die Aktion* published by Franz Pfemfert, which prints drawings and prose poems by him.

1914 Egon Schiele enters his unfinished picture *Encounter* (fig. 46) (now known only from a photograph) for the 1913 Carl Reininghaus Prize. In January and February all the works entered by a total of 25 artists are exhibited in the Salon Gustav Pisko, but Schiele does not win the first prize he hoped for, which goes to Gütersloh.

Austria-Hungary's declaration of war on Serbia on 28 July ushers in the First World War. By reason of his somewhat sickly constitution, Schiele is initially rejected for military service and is thus able to carry on working as an artist.

He takes part in a number of national and international exhibitions, for example in Dresden, Hamburg, Munich and Cologne, as well as Rome, Brussels and Paris.

In the spring, Schiele gets the Viennese painter and graphic artist Robert Philippi to instruct him in the arts of woodcut and etching. He catches the eye of the art collector Heinrich Böhler, who not only takes lessons from him, but also becomes a new and important sponsor and collector. Together with the photographers Josef Trčka and Johannes Fischer, Schiele creates a series of experimental photographic self-portraits. He makes contact with the sisters Edith (1893–1918) and Adele (1890–1968) Harms, whose family owns the house opposite his studio. His sister Gertrude marries his friend Anton Peschka.

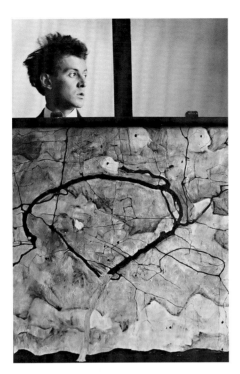

43 Egon Schiele behind the
painting *Autumn Tree in Movement
(Winter Tree)* on an easel, 1912,
Leopold private collection,
photo: Atelier Ungar, Neulengbach

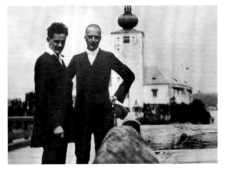

44 Egon Schiele and Arthur Roessler
outside Schloss Orth in the Salzkammergut, 1913

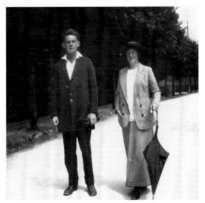

45 Egon Schiele and Wally Neuzil
in Gmunden on the Traunsee, July 1913

1915 At the start of 1915 the Galerie Guido Arnot in Vienna presents paintings, drawings and watercolours by Schiele at a solo exhibition.

Egon Schiele separates from his long-term lover Wally and on 17 June marries Edith Harms in Vienna. The couple then departs for a three-month honeymoon in Prague. Here Schiele begins his military service, after a second medical examination declares him fit. Following basic training in Jindřichův Hradec (Neuhaus) in Bohemia, Schiele is sent to Atzgersdorf south of Vienna as a guard, escorting Russian and other prisoners of war, whom he takes the opportunity to draw. Schiele is able to use his off-duty moments to pursue his artistic activity.

1916 Schiele takes part in the *Wiener Kunstschau*, an exhibition held by the Munich Secession, and is represented in the Galerie Goltz and at the graphic art exhibition in Dresden. The periodical *Die Aktion* brings out an Egon Schiele issue. From the beginning of March to the end of September, Schiele keeps a war diary. At the beginning of May he is transferred to the camp for captured enemy officers in Mühling (Lower Austria), to which he is accompanied by his wife, where he serves as a secretary. Here too he produces a series of drawings of Russian and Austrian officers.

1917 In January Schiele is transferred to Vienna and returns with Edith to Hietzing. He is commissioned to draw the warehouses and branches of his army base. For this purpose he travels in the company of the art and antiques dealer Karl Grünwald to Tyrol. Grünwald will later act as an agent for a number of Schiele's late works. Together with Gütersloh, Schiele is entrusted with the organisation of the *Kriegsausstellung 1917* ("War Exhibition 1917") in the Prater in Vienna.

Together with artists such as Gustav Klimt, Josef Hoffmann, Arnold Schoenberg, Anton Hanak and Peter Altenberg, Schiele plans to found an art gallery, similar to the Secession, as part of the post-war reconstruction effort. The project fails for lack of money. Schiele is represented at exhibitions in Vienna, Munich, Amsterdam, Stockholm and Copenhagen.

46 Schiele by his painting *Encounter*, completed in 1913 (whereabouts unknown), 1914, photo: Anton Josef Trčka

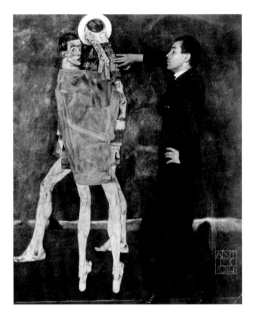

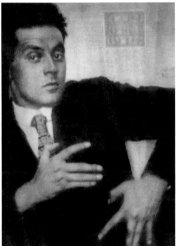

47 Schiele posing, 1914, photo: Anton Josef Trčka

48 Egon Schiele with his collection of folk objects (top left in the box his copy of the *Blauer Reiter* almanac), taken in his studio at Hietzinger Hauptstrasse 101, Vienna 13th district, 1916, photo: Johannes Fischer

1918 Gustav Klimt dies on 6 February in the Allgemeines Krankenhaus (General Hospital). The next day, Schiele makes three drawings of him as he lies in the hospital mortuary.

The presentation of 19 paintings and 29 drawings in the main hall of the 49th exhibition of the Vienna Secession represents Schiele's definitive breakthrough. His portrait of *Edith Schiele, Seated* is acquired by Franz Martin Haberditzl, the director of the Moderne Galerie (today, the Öster-reichische Galerie Belvedere). He thus becomes the first (and only) Austrian museum director to buy a Schiele painting during the artist's lifetime. The great success sparks numerous commissions. Schiele's works are shown at the Kunsthaus Zürich, the Rudolfinum in Prague and the Galerie Ernst Arnold in Dresden. Oskar Kokoschka having left for Germany the previous year, Schiele is now seen as Austria's leading artist.

Schiele rents a second studio at Wattmanngasse 6 in Hietzing, intending to start an art school in his old one. For the autumn, he plans to take part in the portrait exhibition at the Vienna Secession. In addition, he occupies himself making sketches and a series of unfinished paintings for a mausoleum, addressing themes such as religion, death, resurrection and eternal life.

In the autumn, the Spanish flu pandemic reaches Vienna and claims the life of his wife Edith, five months pregnant, who dies on 28 October. The day before her death, Schiele is still making drawings of her. These are his final works, for he outlives her by just three days. On 31 October Egon Schiele dies at the age of 28 and on 3 November, the day on which Austria-Hungary signs the Armistice, he is buried at the cemetery of Vienna's 13th district in Ober-St.-Veit.

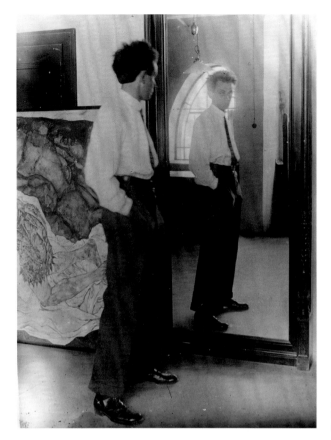

49 Egon Schiele in front of his mirror in the studio in the Hietzinger Hauptstrasse, 1916, photo: Johannes Fischer

50 Egon and Edith Schiele with their nephew Paul Erdmann, 1917, photo: Johannes Fischer

51 Egon Schiele, 1918, photo: Johannes Fischer

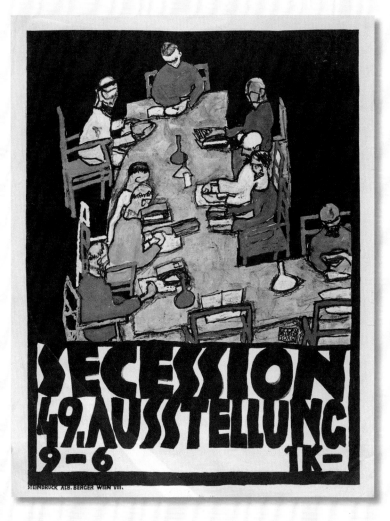

People Round a Table, poster for the 49th exhibition of the Vienna Secession, 1918, lithograph on paper, 68.5 × 53 cm, Leopold Museum, Vienna

ARCHIVE

Letters and Poems
1910 – 1911

*Part of a letter from Egon Schiele to Anton Peschka, c. 1910. It was in 1910
that the two travelled together to Český Krumlov (then known as Krumau)
in Bohemia, the birthplace of Schiele's mother. A few years later, Peschka, his
friend and fellow artist, married Egon's younger sister Gertrude.*

I want to get away from Vienna, as soon as possible. How ugly it is here.
Everyone behaves enviously and deceitfully towards me; former colleagues
look at me with dissembling eyes. In Vienna shadows prevail, the city is
black, everything is prescribed. I want to be alone.
I want to go to the Bohemian Forest.
May, June, July, August, September, October; I must see new things, ex-
plore new things. I want to taste dark waters, see crunching trees, wild airs;
I want to gaze in awe at mouldering garden fences as they all live, hear
young birch groves and trembling leaves; want to see light, sun and enjoy
wet green-blue evening valleys, feel goldfish shine, see white clouds build-
ing, I want to speak to flowers, flowers. Look intently at grasses, pink
people from within, know what venerable old churches and little cathe-
drals are saying; want to keep running without restraint on to rounded
grassy slopes across wide plains; want to kiss the earth and smell warm
mossy flowers, then I will shape such beautifully coloured fields.
Early in the morning I want to see the sun rise again and have the privilege
of looking at the shimmering breathing earth.

2

*In his youth Egon Schiele saw himself as a medium for an enhanced, mysti-
cally understood reality. He felt his existence as standing proud of the mass
and full of rare, "distinguished" qualities. He wanted to "give back" this gift,
this talent, as a present, and through his art he realised what here is called
"loving everyone". In the poetic entanglement of uniqueness and burning
himself out for everyone, therefore, both death – of the individual self – and
life – which is greater than the self – are contained.*
*The feeling of being linked in to everyone and everything is expressed time
and again in Schiele's early poems. It goes hand-in-hand with a synaesthetic
experience of the world, in which colours have taste, moods have voices,
landscapes exert a grip. Everything is sensed, heard, felt, as though there*

I

I *Sun Tree,* 1910, black chalk and gouache on paper, 39.5 × 31.5 cm
Leopold Museum, Vienna

EIN SELBSTBILD·

ICH BIN FÜR MICH VND DIE, DENEN
DIE DVRSTIGE TRVNKSVCHT NACH
FREISEIN BEI MIR ALLES SCHENKT,
VND AVCH FÜR ALLE, WEIL ALLE
ICH AVCH LIEBE, — LIEBE.

ICH BIN VON VORNEHMSTEN
 DER VORNEHMSTE
 VND VON RÜCKGEBERN
 DER RÜCKGEBIGSTE

ICH BIN MENSCH, ICH LIEBE
 DEN TOD VND LIEBE
 DAS LEBEN.

1910.

2

were no distance and essentially no difference between subject and world. Everything is alive and everything is, just like the poetic I, doomed to die. What is expressed in Schiele's poem is an intense experience of existence, which in some passages touches the reader as being original and authentic, while coming across in others as an artistic exercise, a laboured reaction to poems by Rimbaud and Rilke.

In the series of poems and letters, in the poetic emphasis and in the statements relating to works, there is however in the end a continuity that shows

a concentrated, clearly defined and self-assured will to art– which is aston-
ishing in view of the artist's age at the time.

A PICTURE OF MYSELF

I AM FOR MYSELF AND THOSE TO WHOM
MY AVID THIRST FOR
FREEDOM GIVES EVERYTHING,
AND ALSO FOR ALL, SINCE ALL
I ALSO LOVE – LOVE.

I AM OF NOBLEST
 THE NOBLEST
 AND OF GIVERS-BACK
 THE MOST GIVING-BACK

I AM A MAN, I LOVE
 DEATH AND LOVE
 LIFE.

3
*Letter-card from Egon Schiele to one of his early collectors, Oskar Reichel,
1911 – the reference is either the painting* The Lyric Poet *or* Self-Seer II *or
both together.*

Dear Dr O. R. I know, without wishing to flatter you, no one in Vienna
more knowledgeable about art than you are. – And so I have sent/selected
for you this my picture from the completely new series. – After a while you
will be so completely convinced by it, as soon as you begin not to look at it
but into it. The picture is the one about which G. Klimt has said he would
be glad to see such faces. – It is confident, contemporary, the greatest thing
that has been painted in Vienna. – He who laughs about it, one should look

2 Poem *A Picture of Myself*, 1910, ink on paper, 30 × 19.1 cm
Leopold Museum, Vienna

how he laughs, for he is hostile to my art, envious of my art etc. why should I always be silent when it is the truth.
E.S.

4

Arthur Roessler introduced Schiele to the dentist and early Schiele collector Hermann Engel. In this letter, Egon Schiele describes the thoughts and feelings that moved him as he was painting the work Revelation.

September 1911.
Dear Dr. E.

"The Revelation"! – The Revelation of the living being involved; it may be a poet, an artist, a scholar, a spiritist. – Have you ever felt what kind of impression a great personality exerts on the world around him? (…) The one half is then intended to portray the vision of a man so great that the one thus influenced and captivated kneels down, bows down be-

fore the greatness which sees without opening its eyes, which decays, and from which the astral light emanates orange or in other colours, in such excess that the one bowing down flows, hypnotised, into the great one. (…) What I mean is that the small kneeling figure melts into the radiant great one. – On the right everything is red, orange, saturated brown while on the left then is the similar being, which different in kind stands on equal terms with the large one on the right. – (Positive and negative electricity unite.) What it's supposed to mean is that the small kneeling figure fuses into the large radiant one. That's something about my picture. "The Revelation"!

Egon Schiele.

3 Portrait of Dr. Oskar Reichel, 1910, black chalk on paper, 41.8 × 29.8 cm
Leopold private collection
4 Letter from Egon Schiele to Hermann Engel, dated 1 September 1911
Indian ink on paper, 22.5 × 28.8 cm, Leopold Museum, Vienna

SOURCES

PICTURE CREDITS

The originals were kindly placed at our
disposal by the Leopold Museum, Vienna,
or as the case may be by the museums and
collections listed below:
(the figures indicate the page numbers)

akg images: 61 below, 65 below left
Albertina, Vienna: 23, 35, 56, 59 above, 65 below,
 67 middle, 67 below, 69
© Belvedere, Vienna: 49, 50/51, 53
Leopold Museum, Vienna: frontispiece, 13–21,
 24–33, 36–47, 54, 59 below left, below right, 61
 above, 65 above, 67 above, 70, 73, 74, 76, 77
© Wien Museum: 10

TEXTUAL EXCERPTS WERE TRANSLATED FROM THE FOLLOWING SOURCES:

Letter c. 1910 to Anton Peschka. In: Elisabeth
 Leopold (ed.): *Der Lyriker Egon Schiele. Briefe
 und Gedichte 1910–1912 aus der Sammlung
 Leopold*, Munich, Prestel Verlag, 2008,
 pp. 13–15: 12, 72 and p. 73: 75/76 and p. 87: 76/77
Jean-Arthur Rimbaud: *Leben und Dichtung.*
 Translated by K. L. Ammer (pseudonym of Karl
 Anton Klammer). With an introduction by
 Stefan Zweig, Insel-Verlag, Leipzig, 1907: p. 17

Published by
Hirmer Verlag GmbH
Nymphenburger Strasse 84
80636 Munich
Germany

Cover illustration: *Self-Portrait in Striped Shirt* (detail), 1910, see p. 17
Double page 2/3: *Death and Girl* (detail), 1915, see p. 49
Double page 4/5: *Black-Haired Girl with Lifted Skirt* (detail), 1911, see p. 21

www.hirmerpublishers.com

TRANSLATION
Michael Scuffil, Leverkusen

COPY-EDITING/PROOFREADING
Jane Michael, Munich

PROJECT MANAGEMENT
Rainer Arnold

DESIGN/TYPESETTING
Marion Blomeyer, Rainald Schwarz, Munich

PRE-PRESS/REPRO
Reproline mediateam GmbH, Munich

PAPER
LuxoArt samt new

PRINTING/BINDING
Passavia Druckservice GmbH & Co. KG, Passau

Bibliographic information published by the Deutsche Nationalbibliothek
The Deutsche Nationalbibliothek lists this publication in the Deutsche Nationalbibliografie; detailed bibliographic data are available on the Internet at http://dnb.dnb.de.

ISBN 978-3-7774-2852-9

Printed in Germany

THE GREAT MASTERS OF ART SERIES

ALREADY PUBLISHED

www.hirmerpublishers.com